Fragile Beasts
Coloring Book

Illustrations by Magali An Berthon

Edited by Caitlin Condell

New York

COOPER HEWITT

Published by
Cooper Hewitt, Smithsonian Design Museum
2 East 91st Street
New York, NY 10128, USA
cooperhewitt.org

Distribution (U.S.)
ARTBOOK | D.A.P.
155 Sixth Avenue, 2nd floor
New York, NY 10013, USA
artbook.com

Distribution (International)
Thames & Hudson Ltd.
181A High Holborn
London WC1v 7QX
England
United Kingdom
thamesandhudson.com

ISBN: 978-1-942303-16-9

Cooper Hewitt, Smithsonian Design Museum
Pamela Horn
Head of Cross-Platform Publishing
Design: Magali An Berthon
Fonts: Bodoni 72 I HK Grotesk

2016 2017 2018 2019 / 10 9 8 7 6 5 4 3 2 1
Printed in U.S.A.

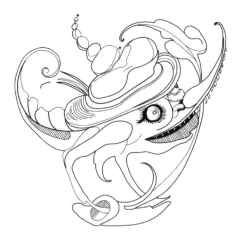

 Smithsonian Design Museum

Introduction

By Caitlin Condell

Welcome to a world of fragile beasts! In the pages of this book, you will encounter creatures real and imagined, created by artists working hundreds of years ago. Within the designs you'll recognize butterflies, snails, birds, rabbits, and dogs. As you color, you will find that strange and mysterious creatures abound—a man with plants for legs; a critter with the spiraling shell of a hermit crab, pincers of a scorpion, hooves of a stag, and the tail of a peacock; a two-legged monster with the head of a bull; and a snail that has alligator heads in place of feet, just to name a few of the more uncommon forms.

In the sixteenth and seventeenth century, European artists who produced these magical creatures had a name for them—*grotesques*. The word *grotesque* suggests many things in modern language, but its origin dates to late fifteenth-century Italy, where *grottesche* translated literally as "of the grotto." The term was coined to refer to images found on the walls of ancient structures that had been buried, including Nero's grand pleasure palace, the Domus Aurea. Lowered into the dirt-filled chambers of the palace, Renaissance artists discovered wall paintings of slender architectural elements framing or transforming into foliage that morphed into human, animal, and mythological forms. From this discovery, the genre of the grotesque was born. This fantastic style enabled artists to invent creatures that pushed the boundaries of the known world. At the end of this book, you can learn more about the prints and drawings from which these beasts originate, all of which are housed in the collection of the Department of Drawings, Prints & Graphic Design at Cooper Hewitt, Smithsonian Design Museum.

Over the next forty pages, elements of nature are transformed into otherworldly beings. Many centuries after they were created, it is time to transform them even more by bringing these fearsome and playful creatures from the Age of Exploration to life with color!

Find your beast !

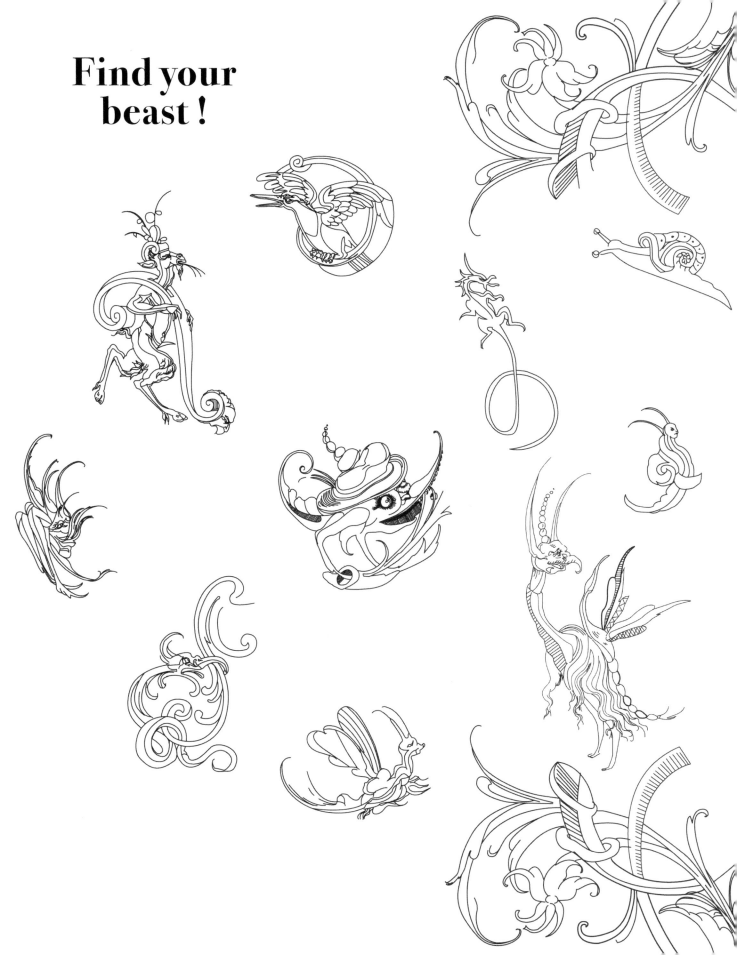

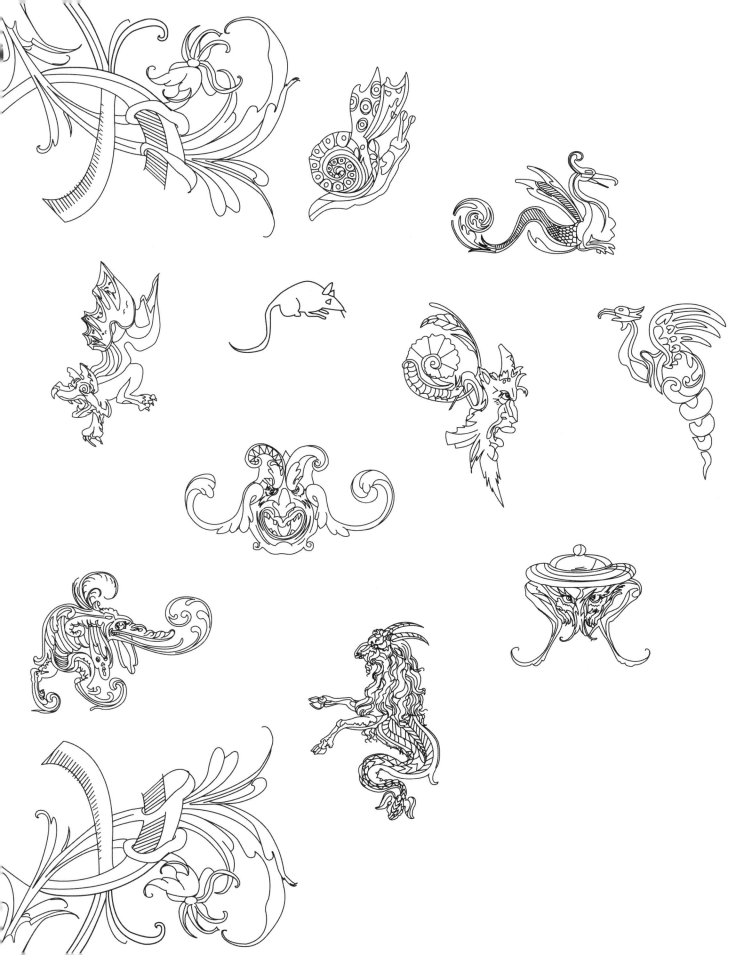

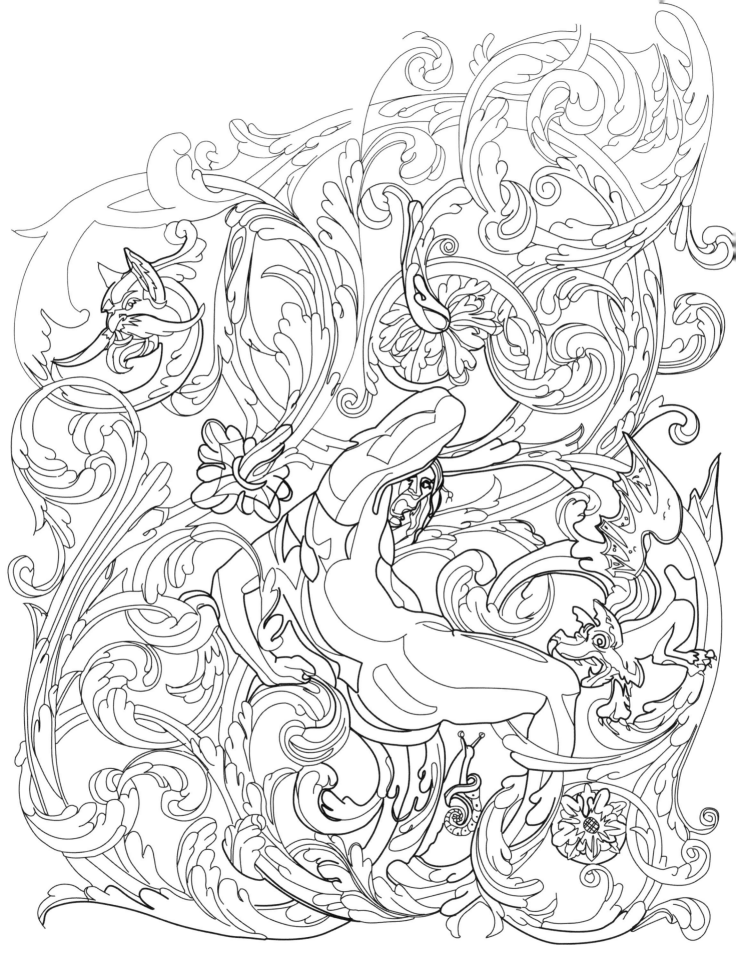

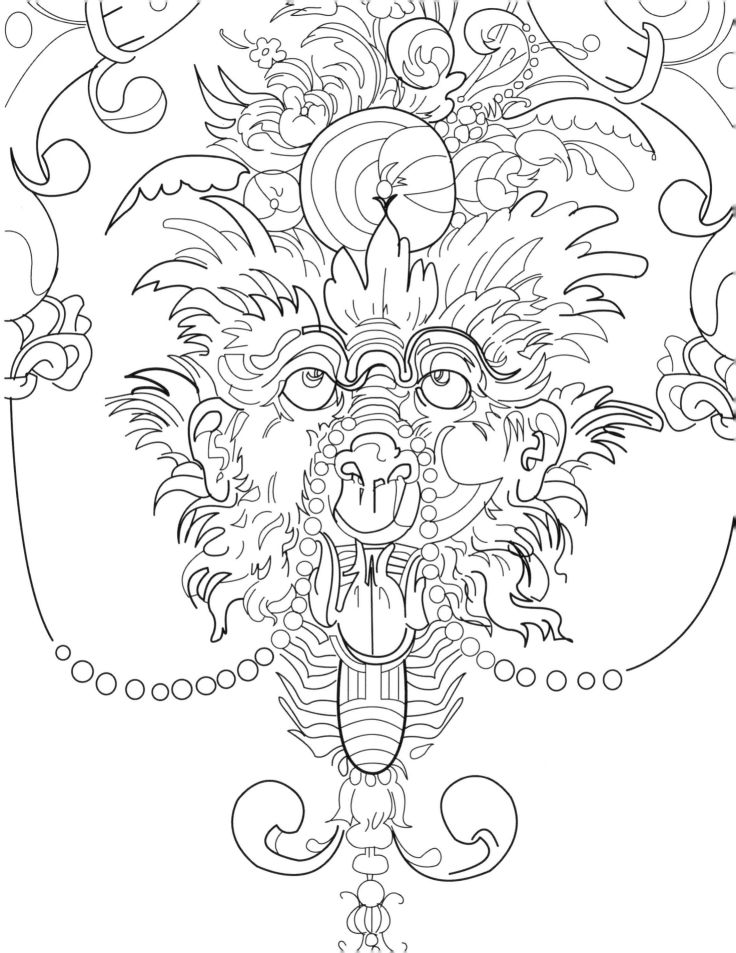

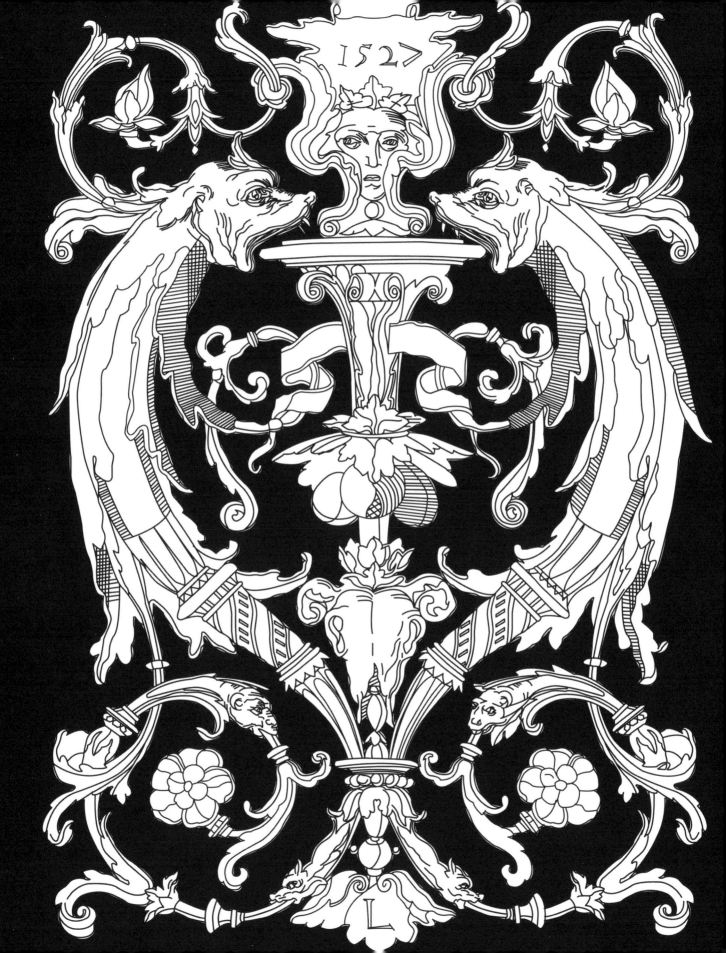

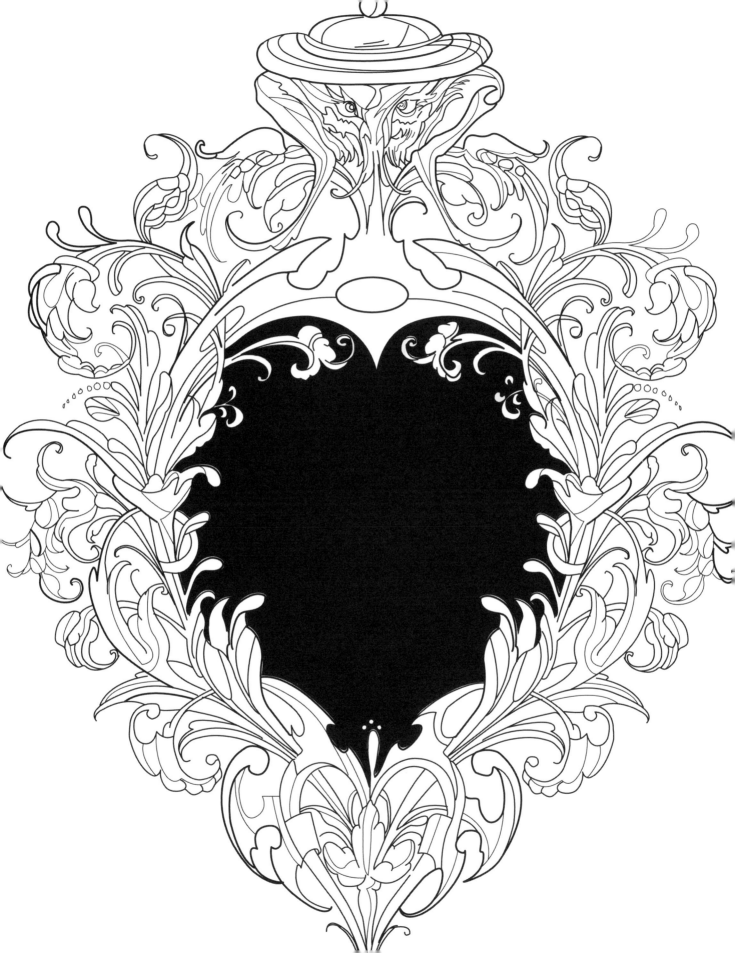

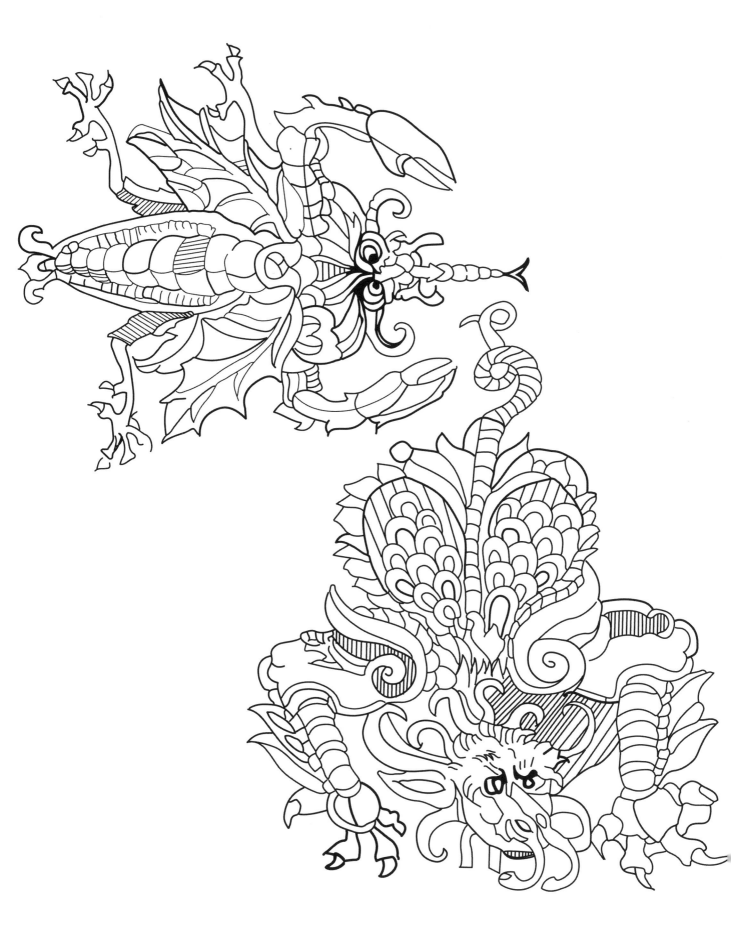

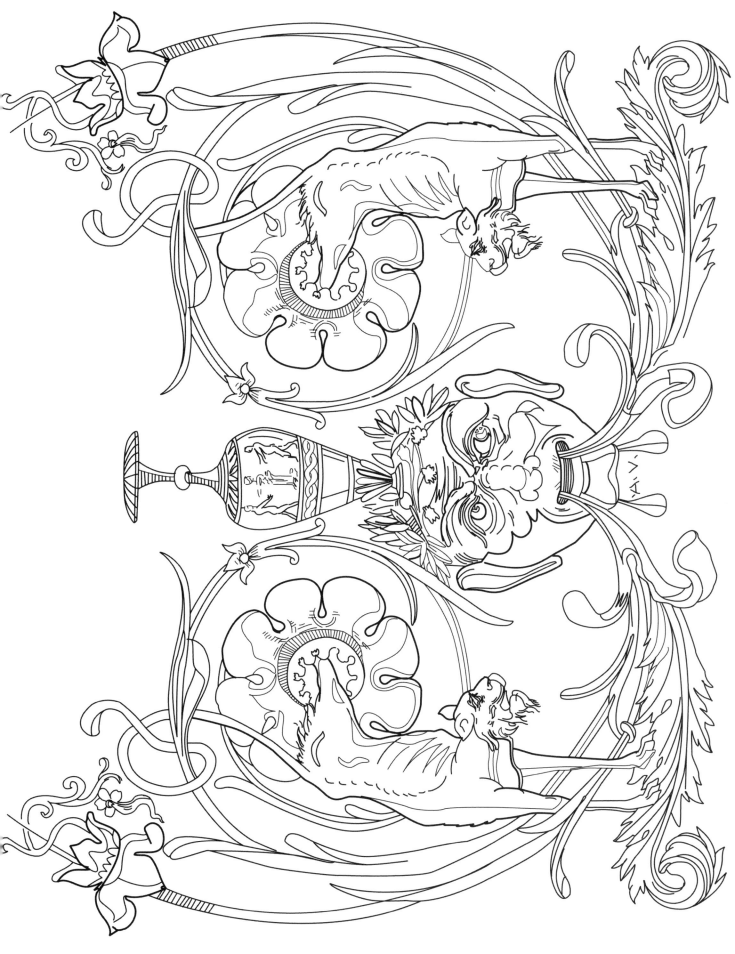

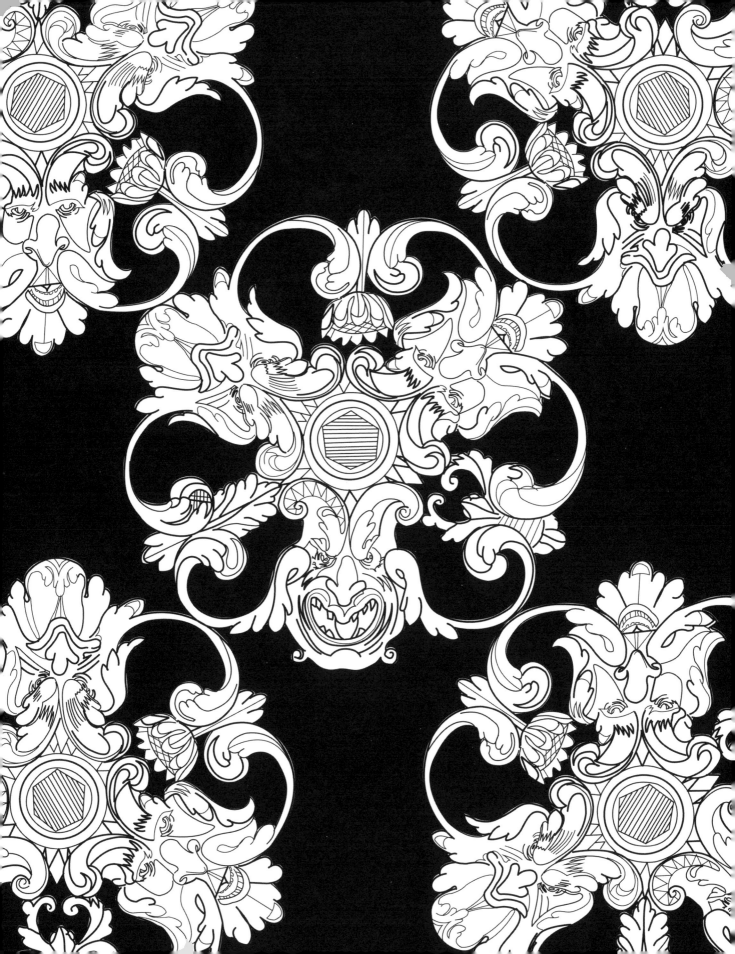

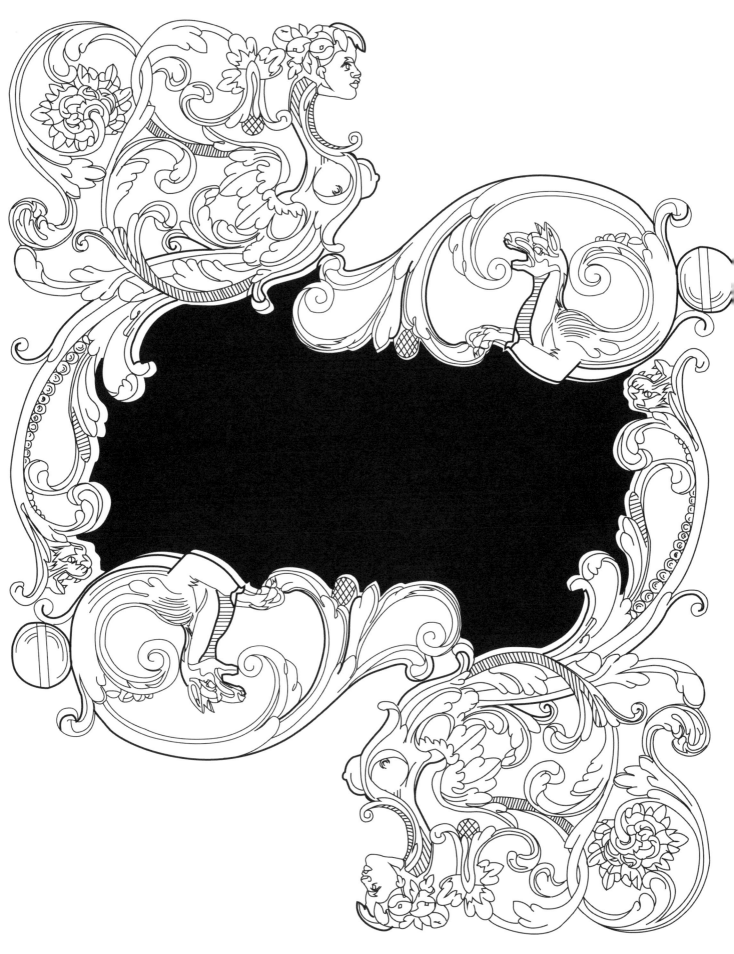

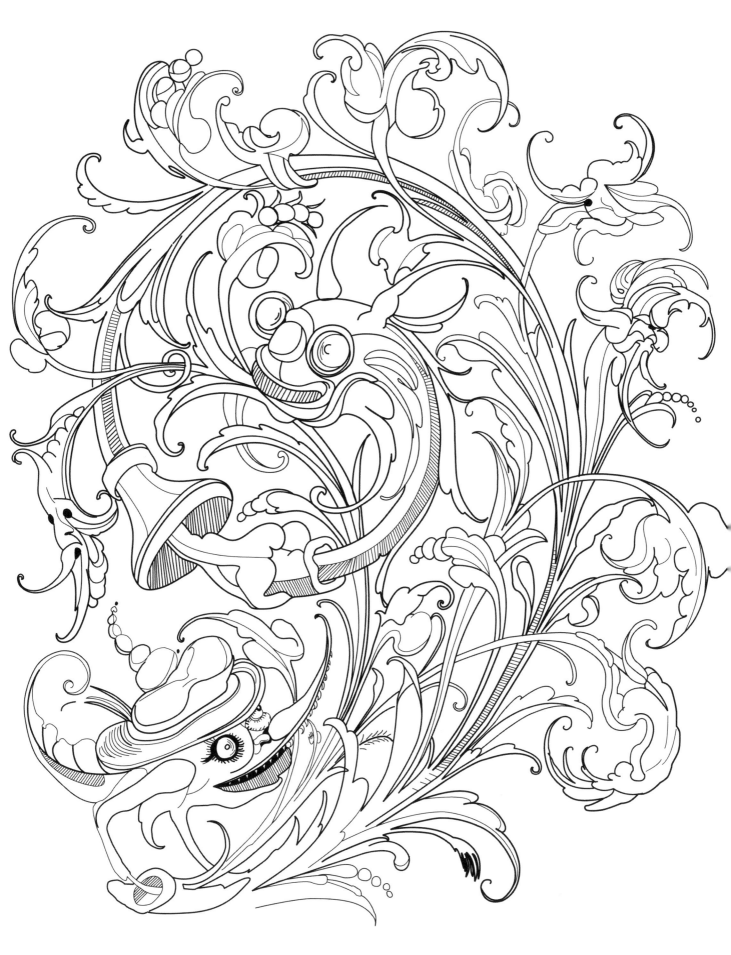

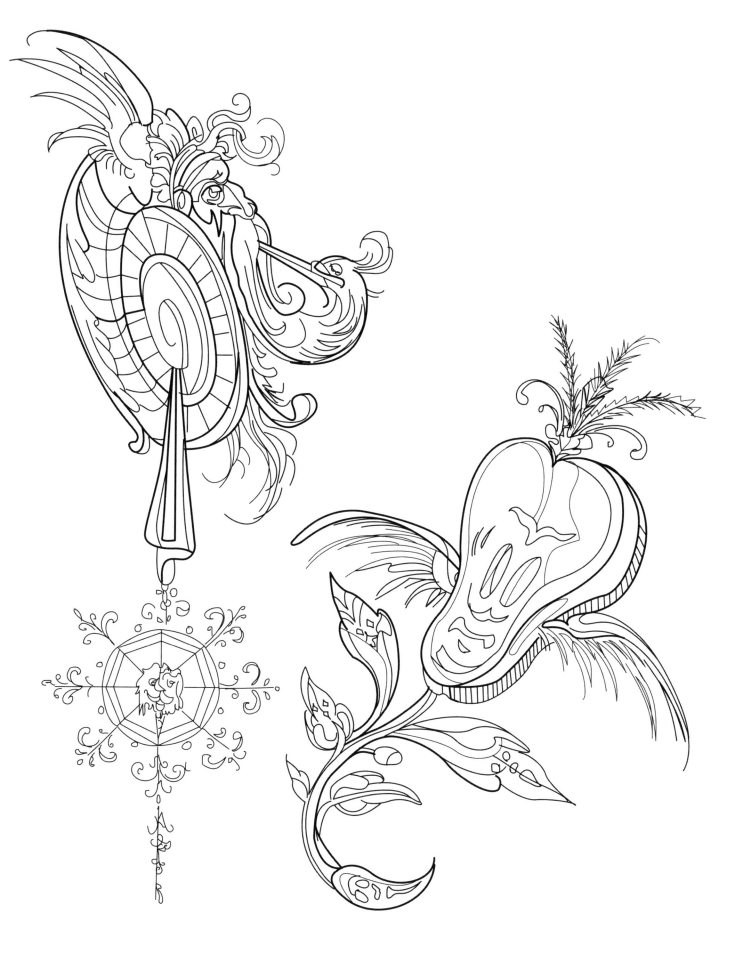

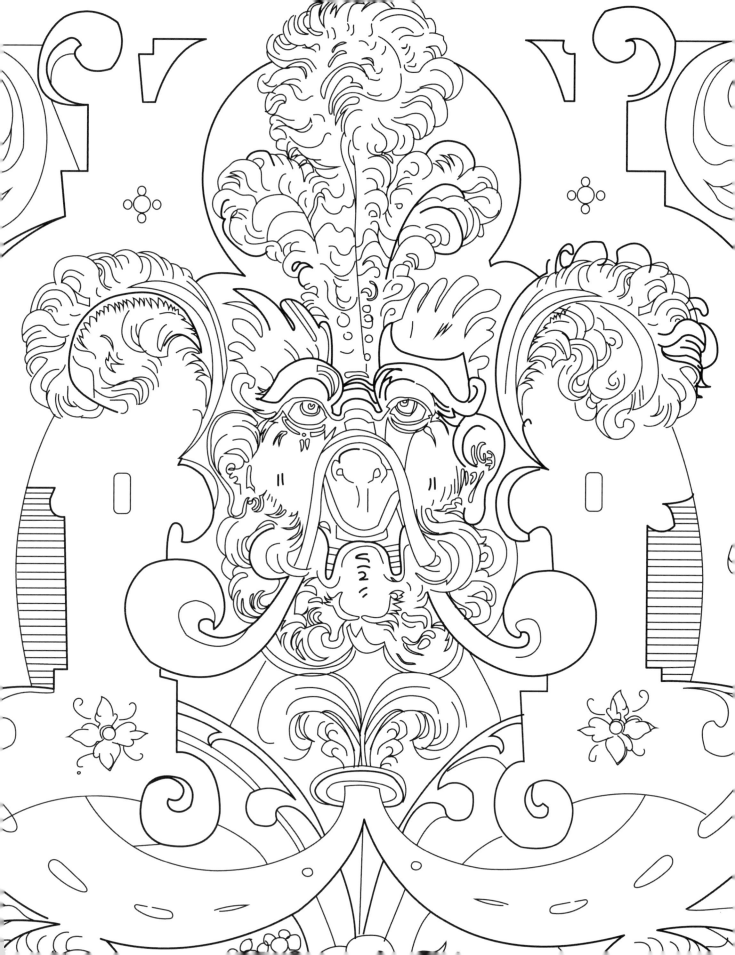

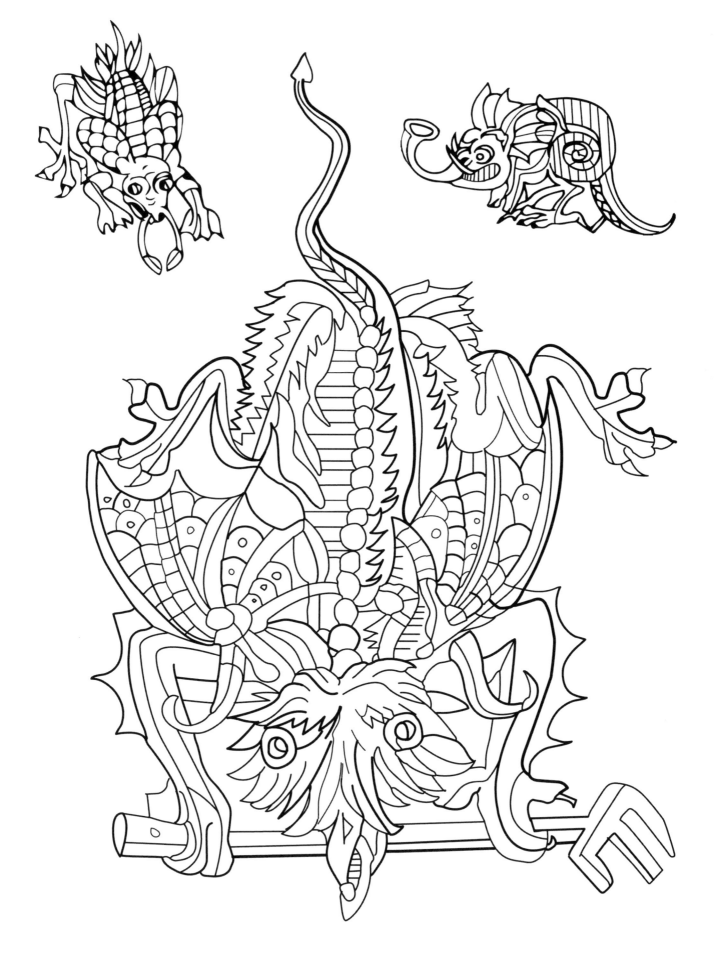

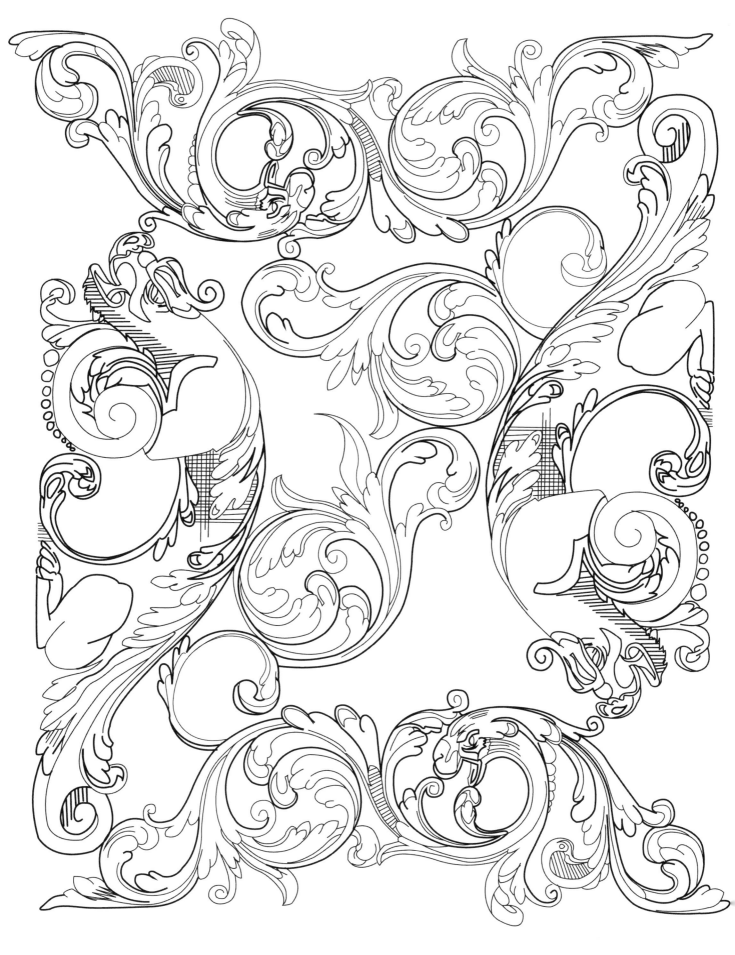

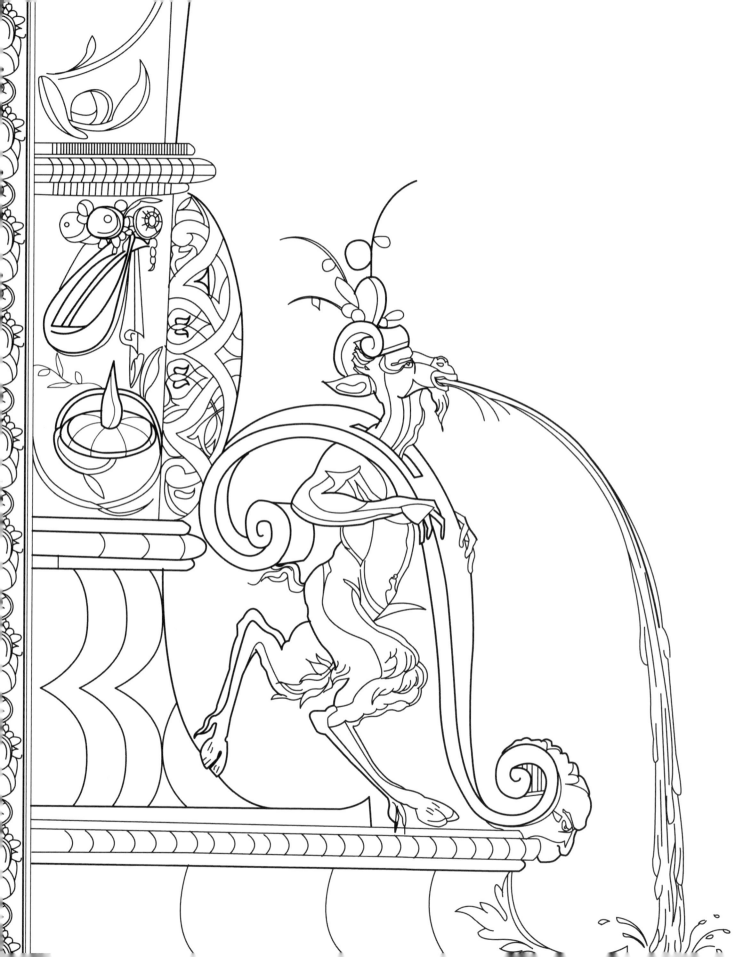

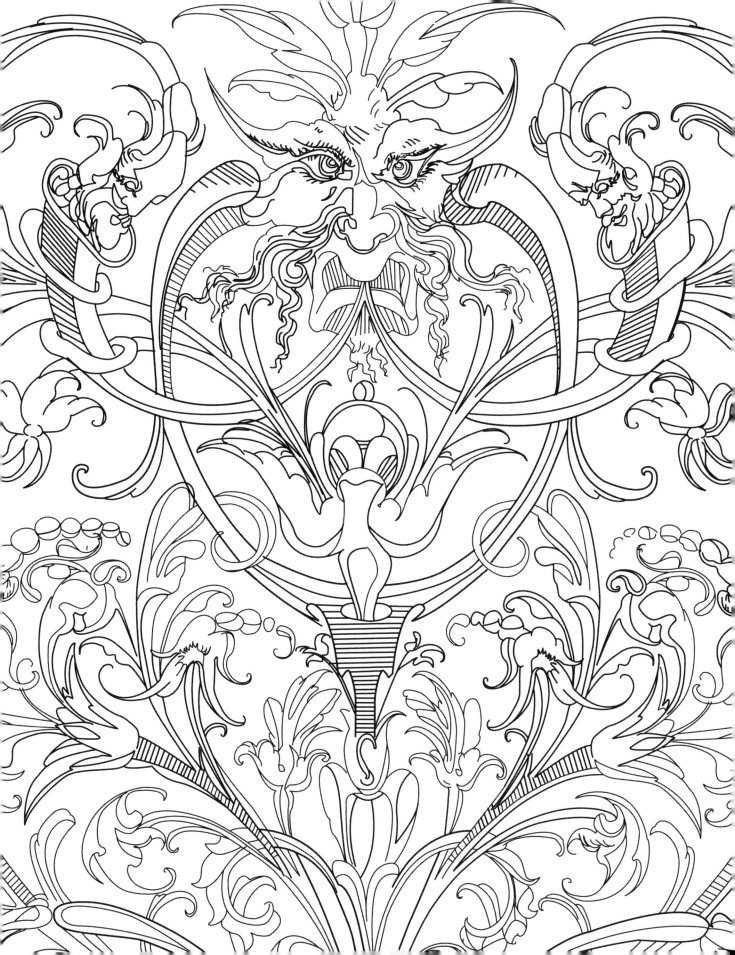

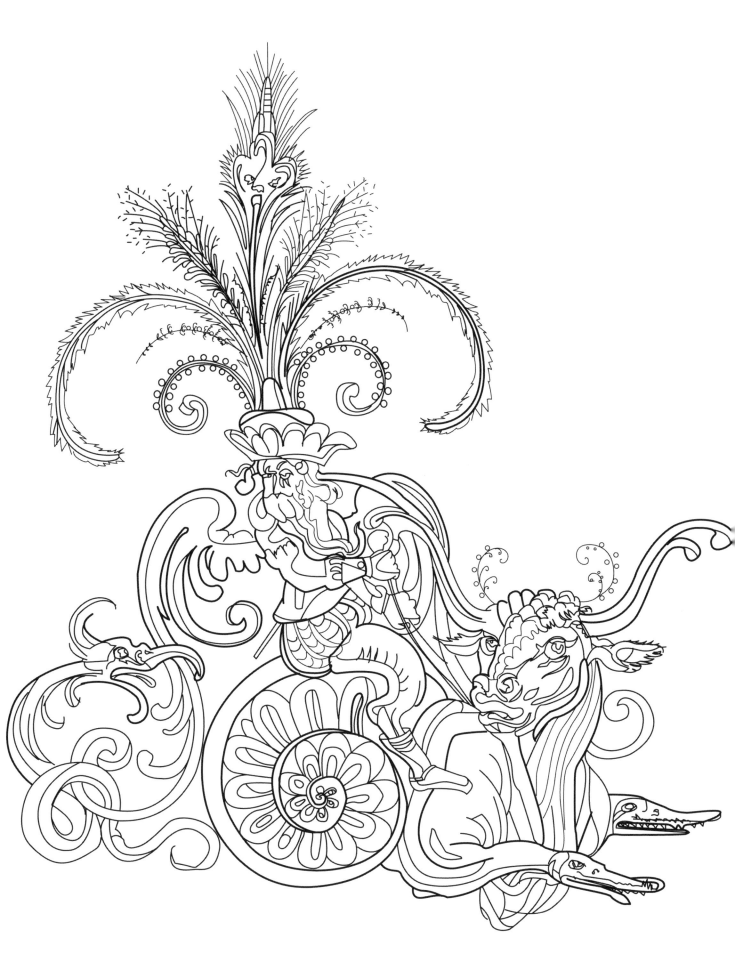

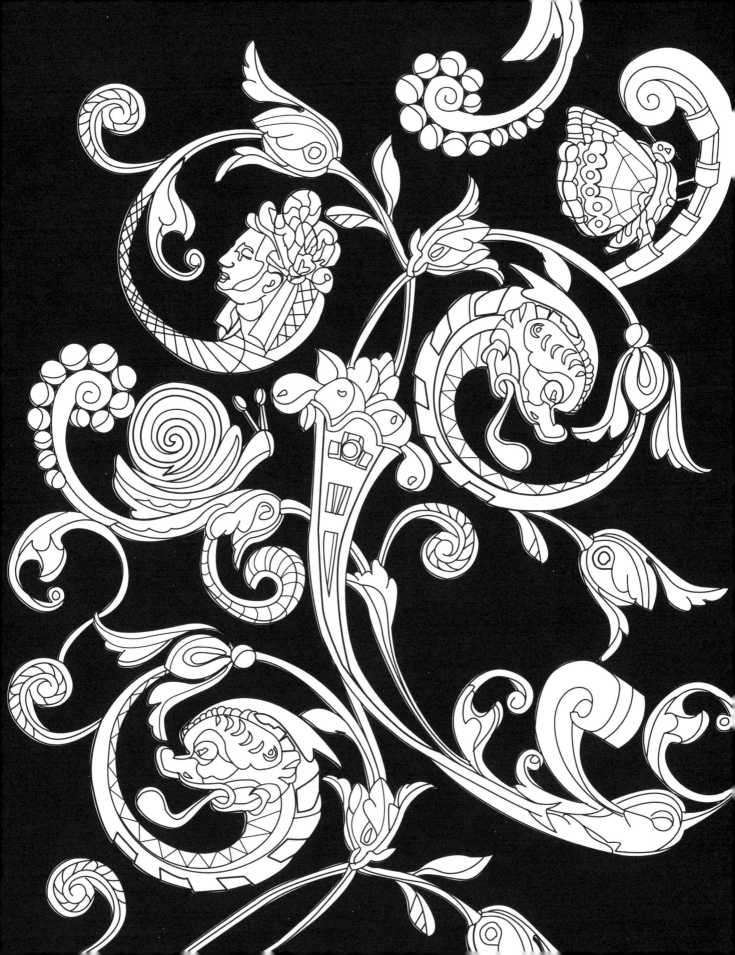

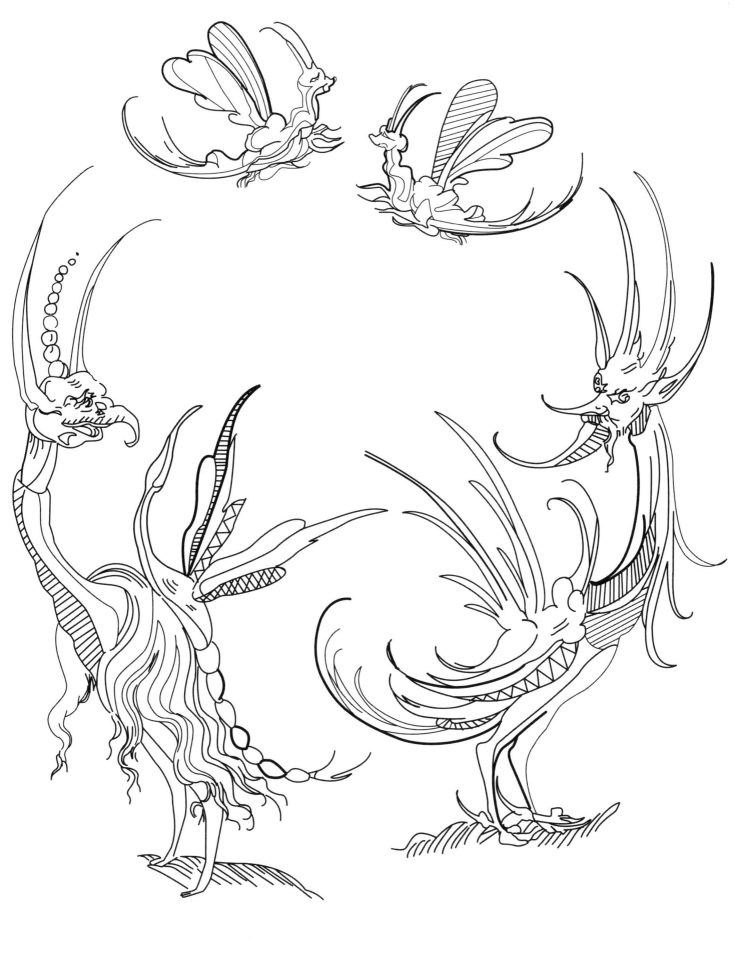

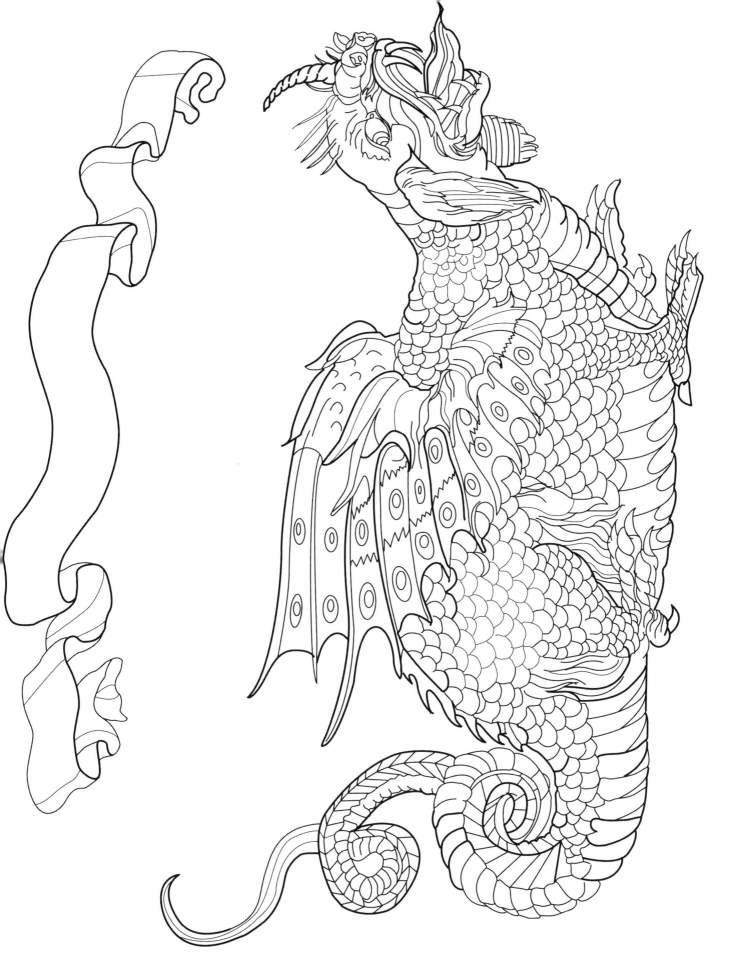

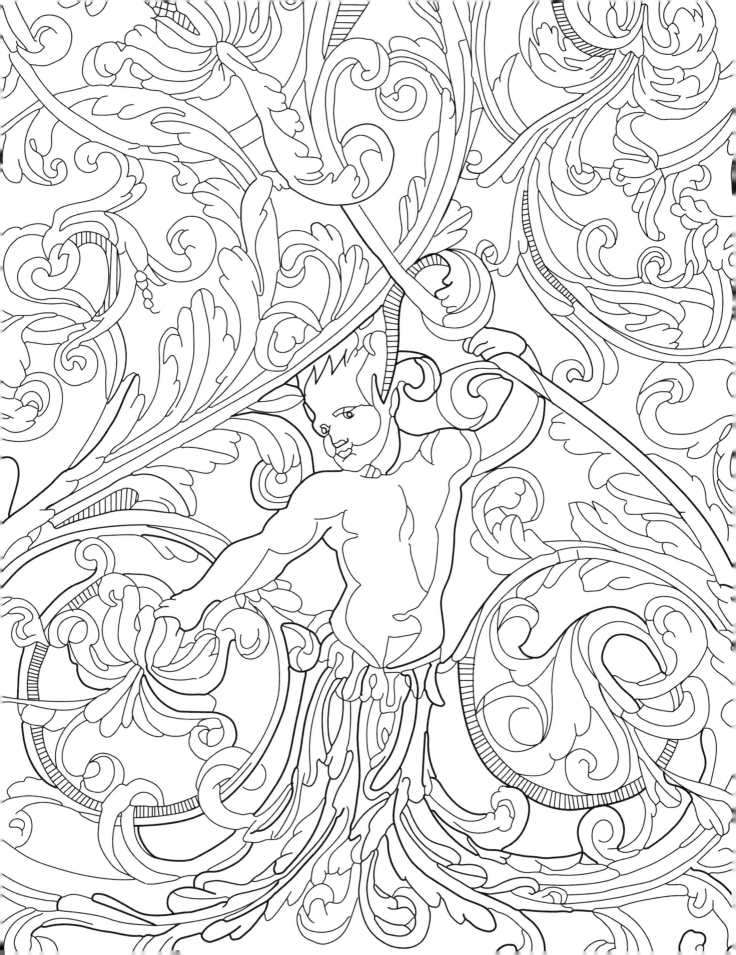

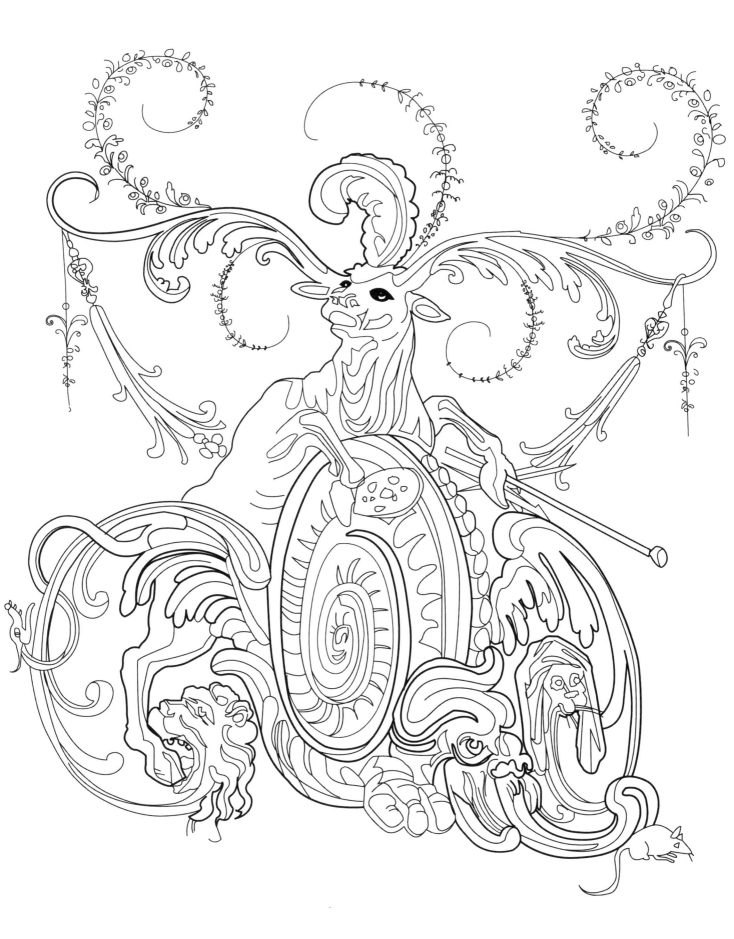

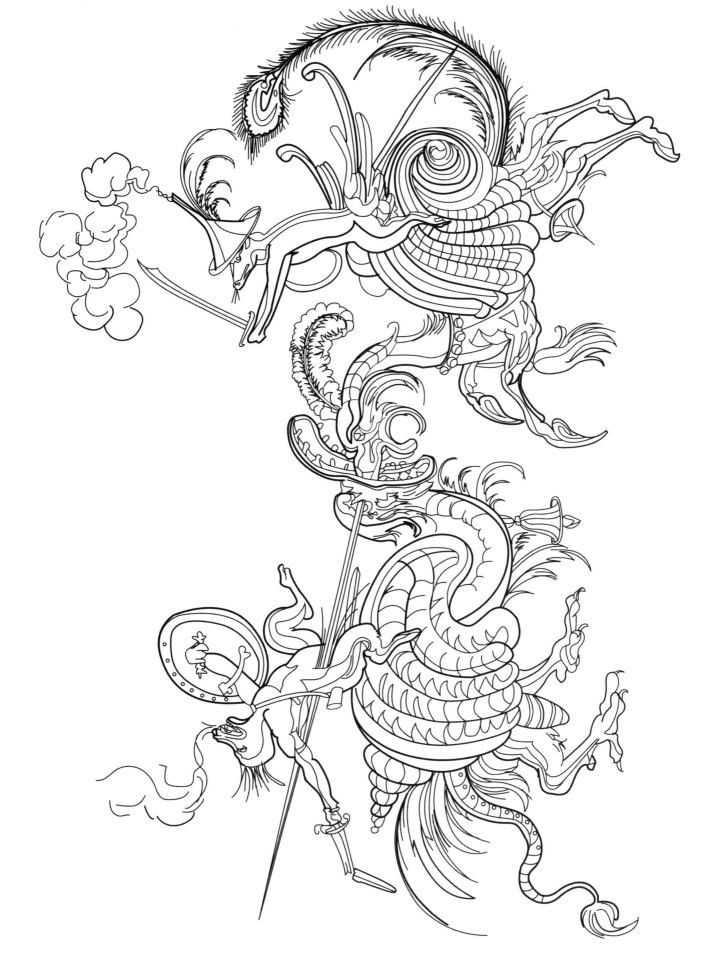

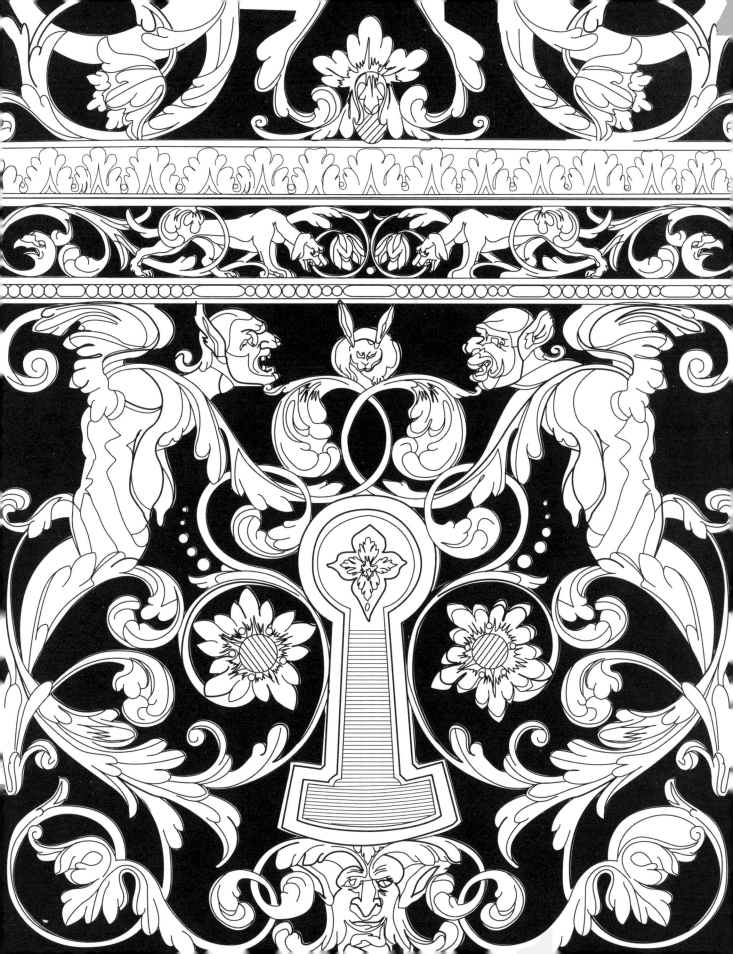

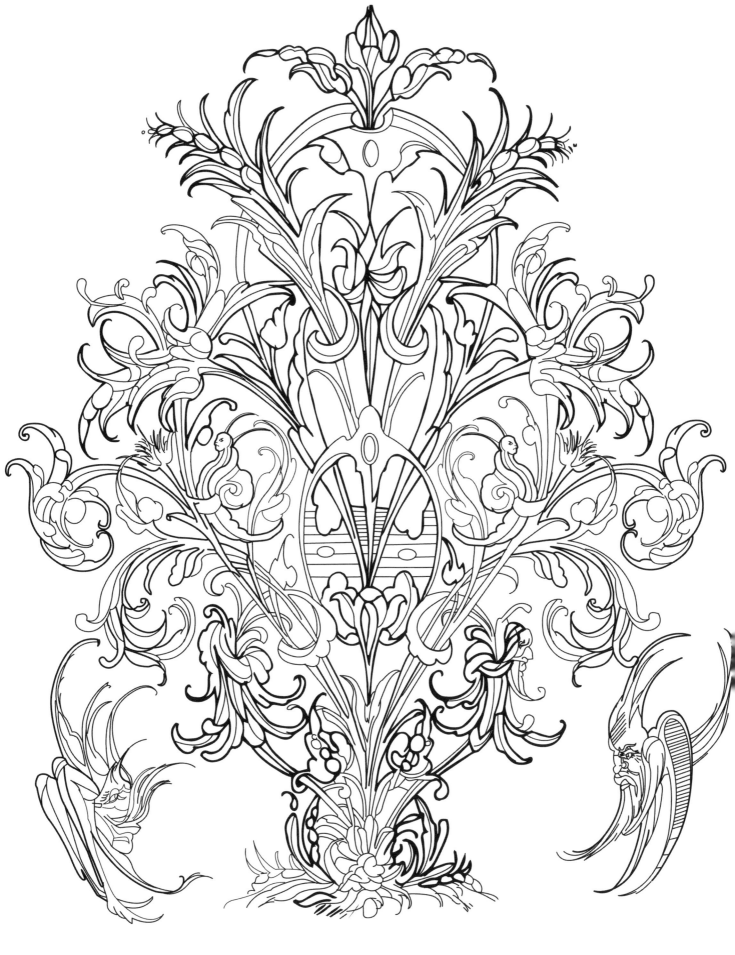

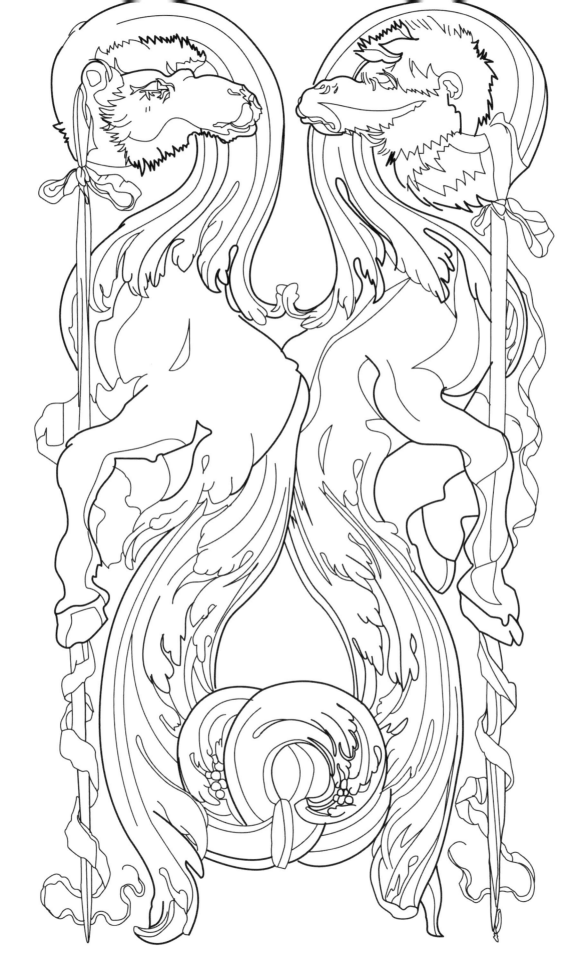

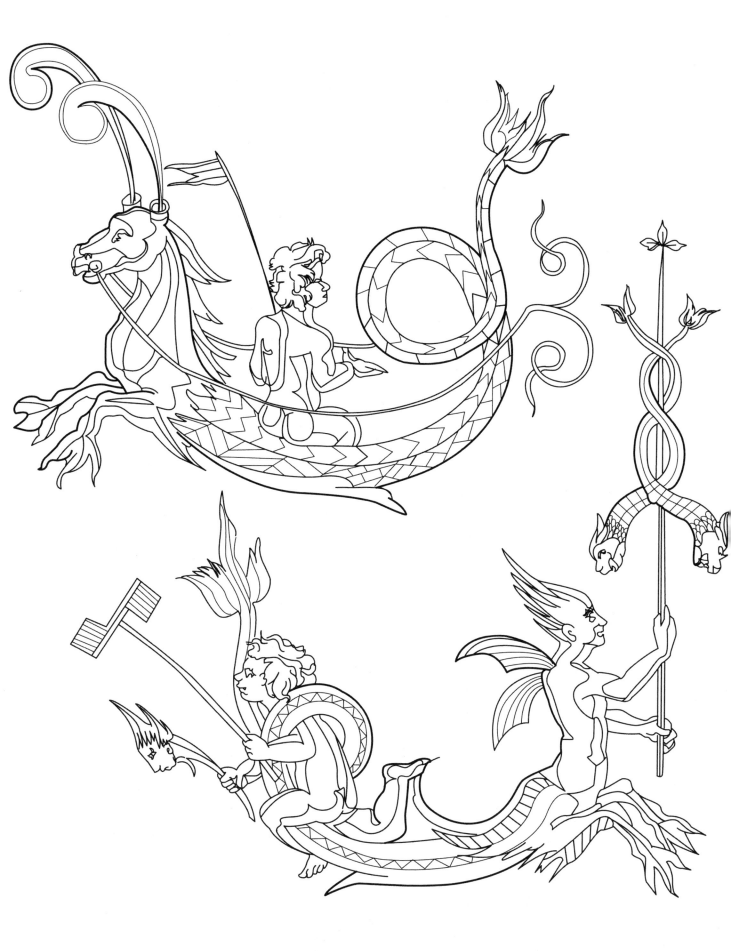

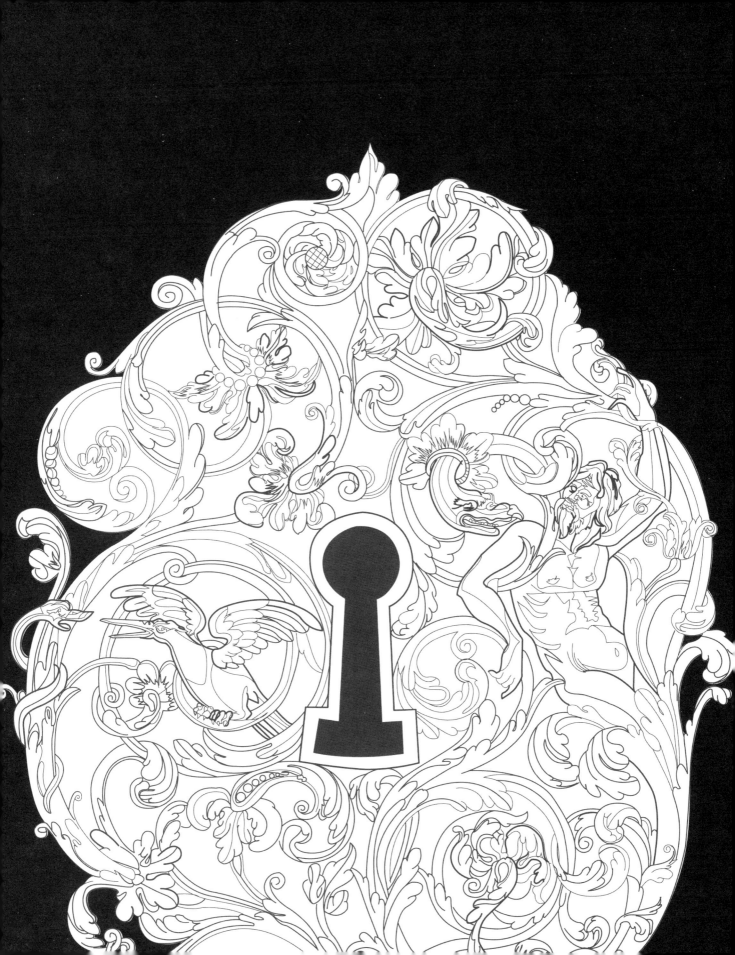

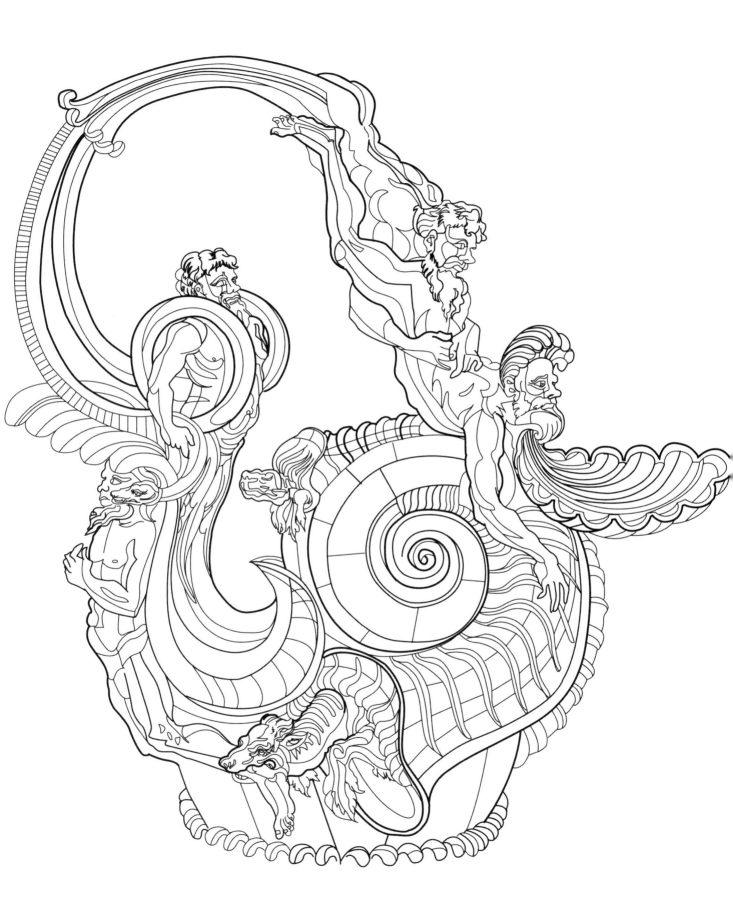

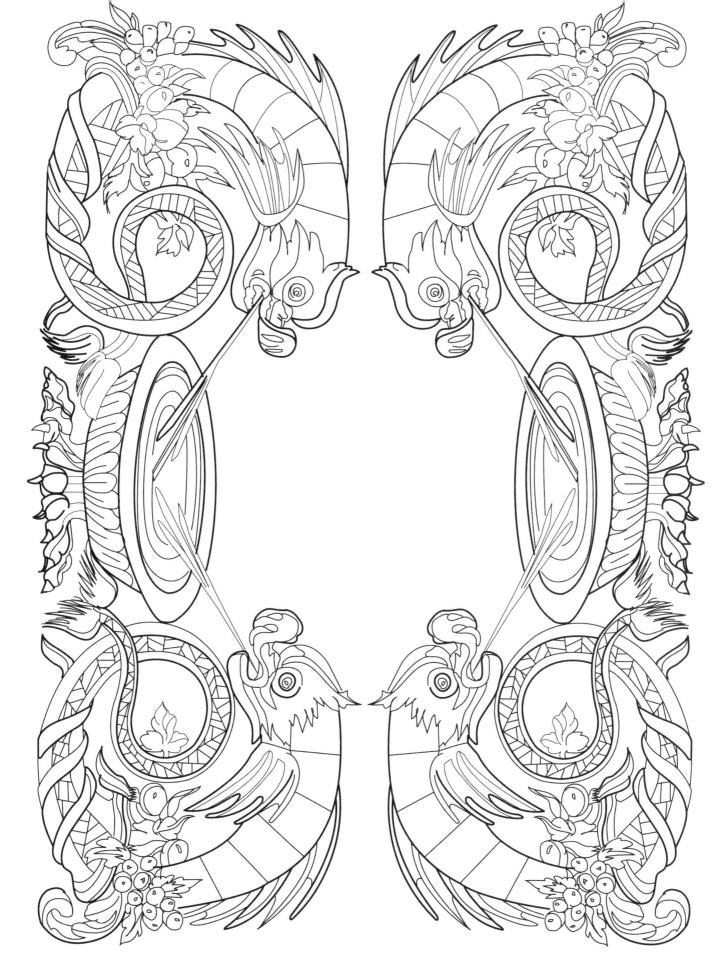

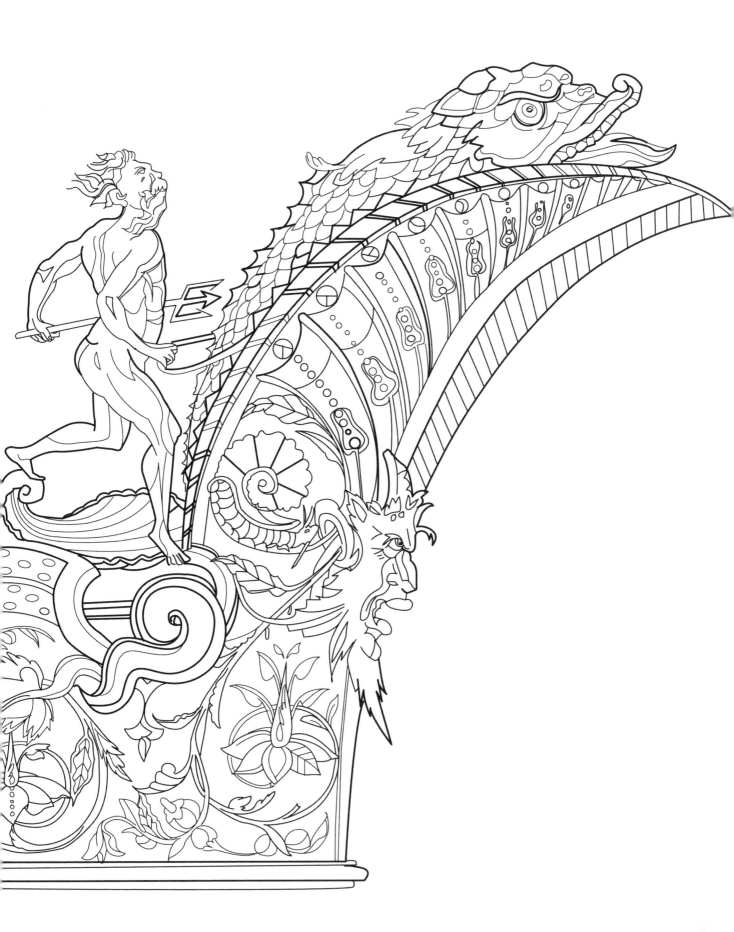

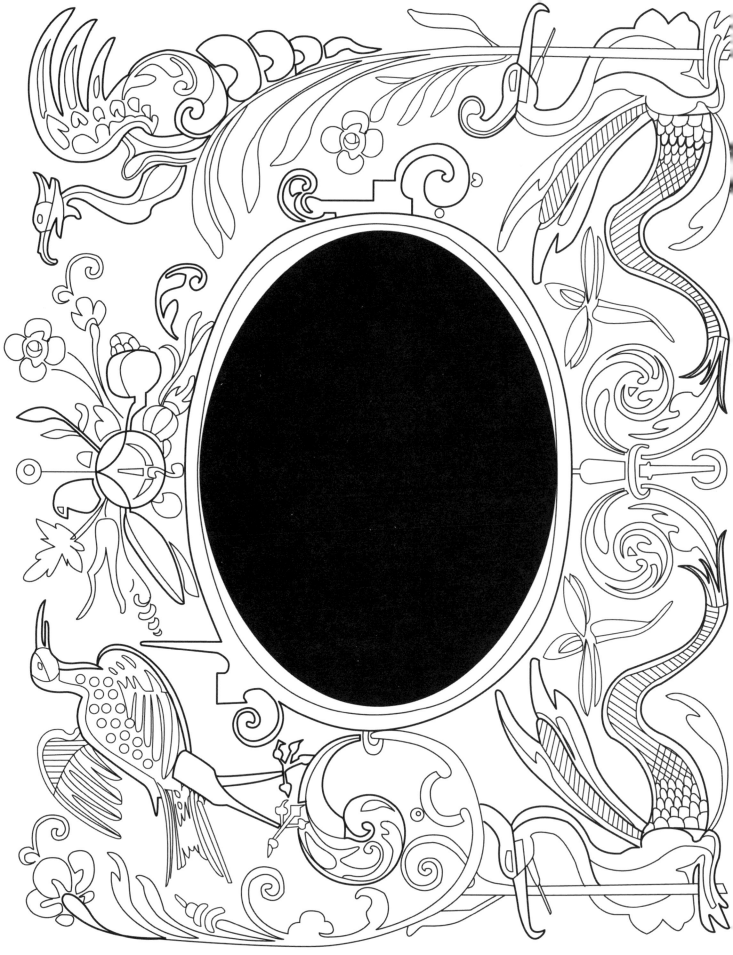

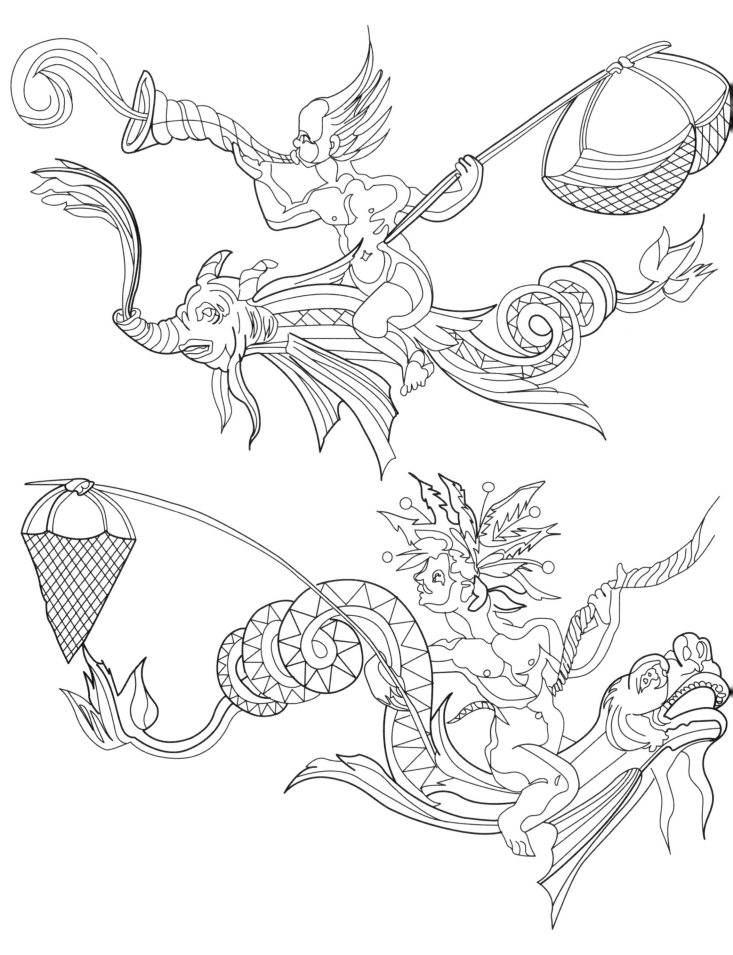

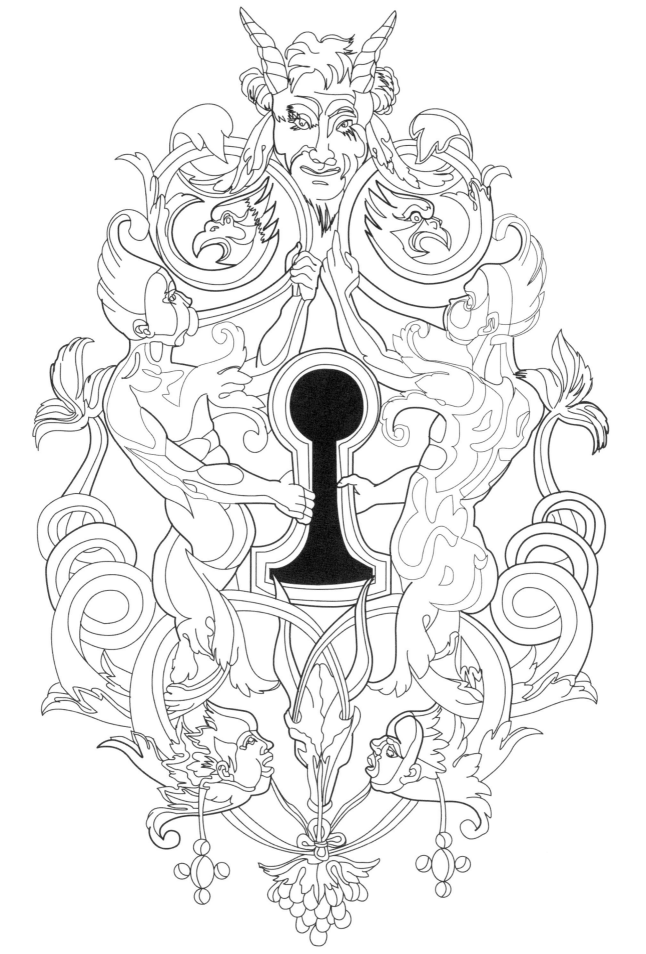

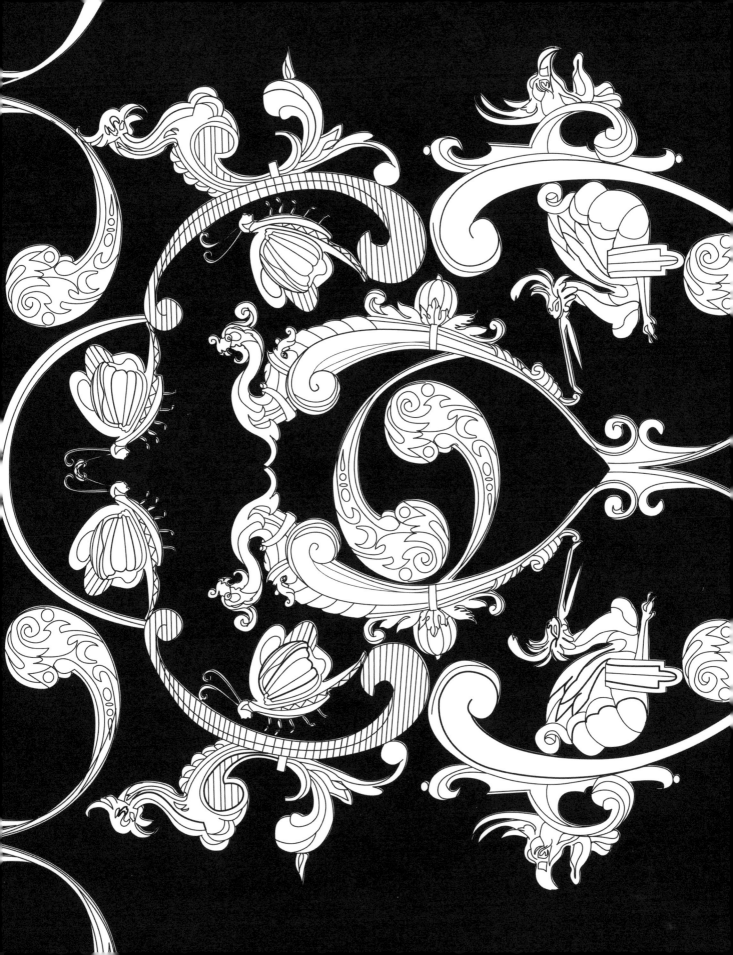

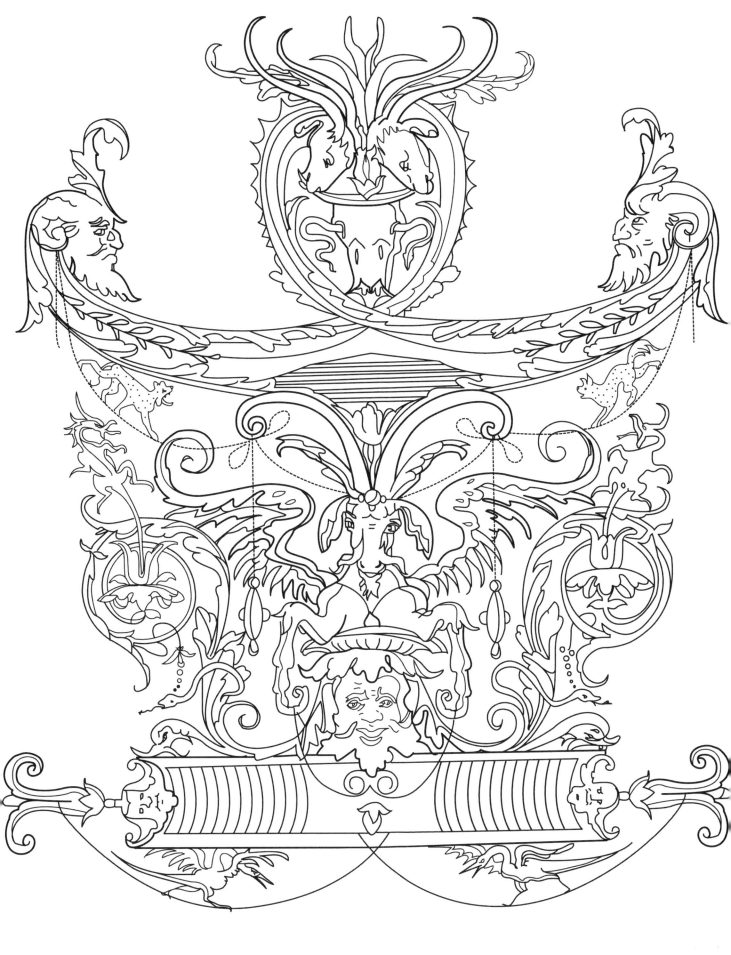

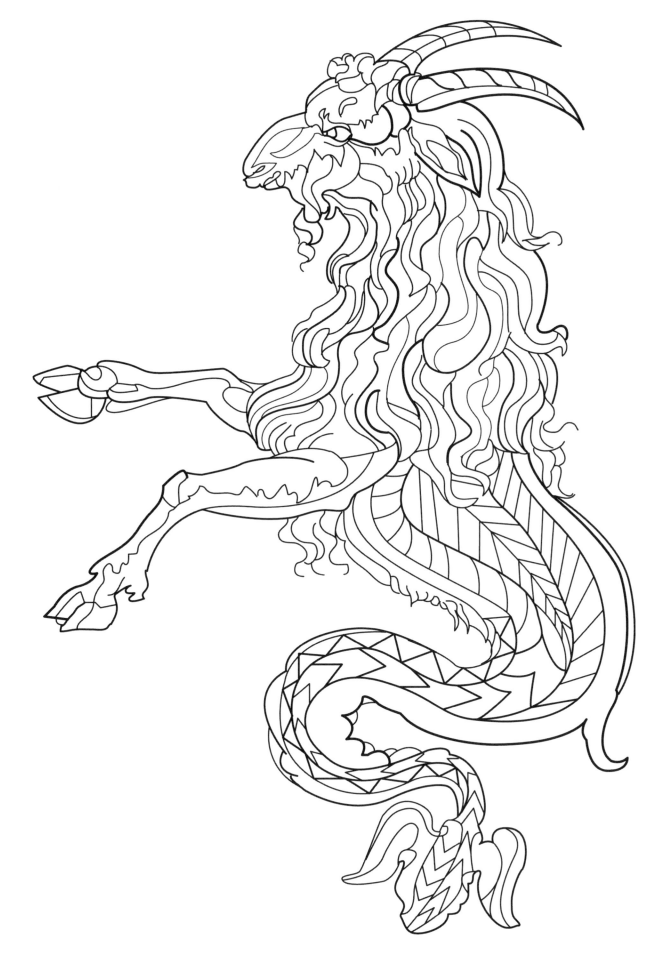

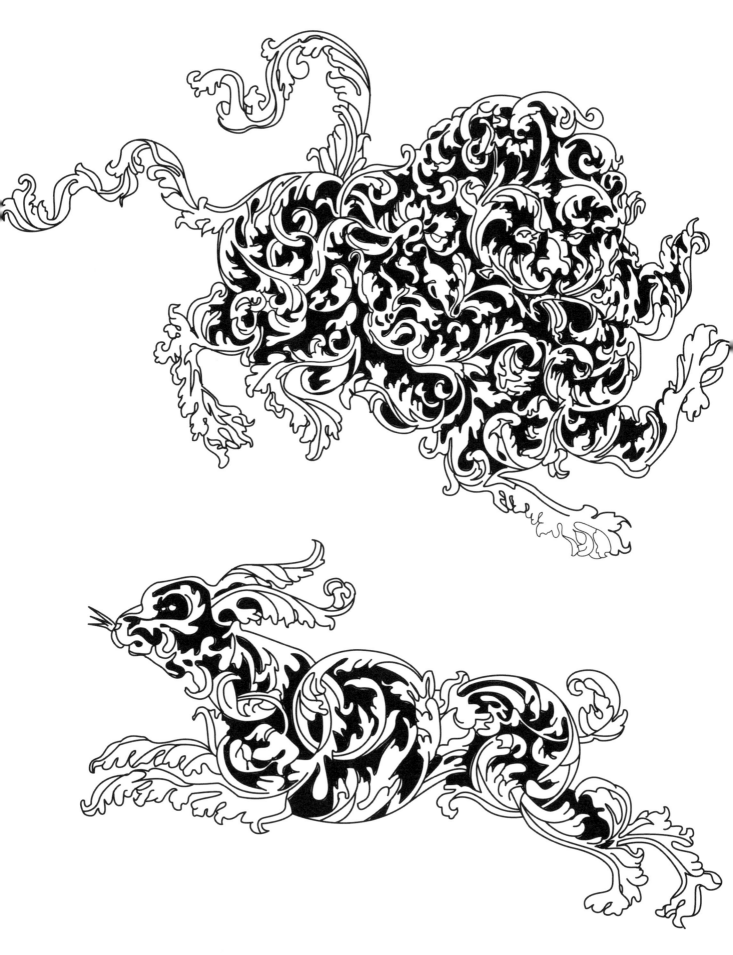

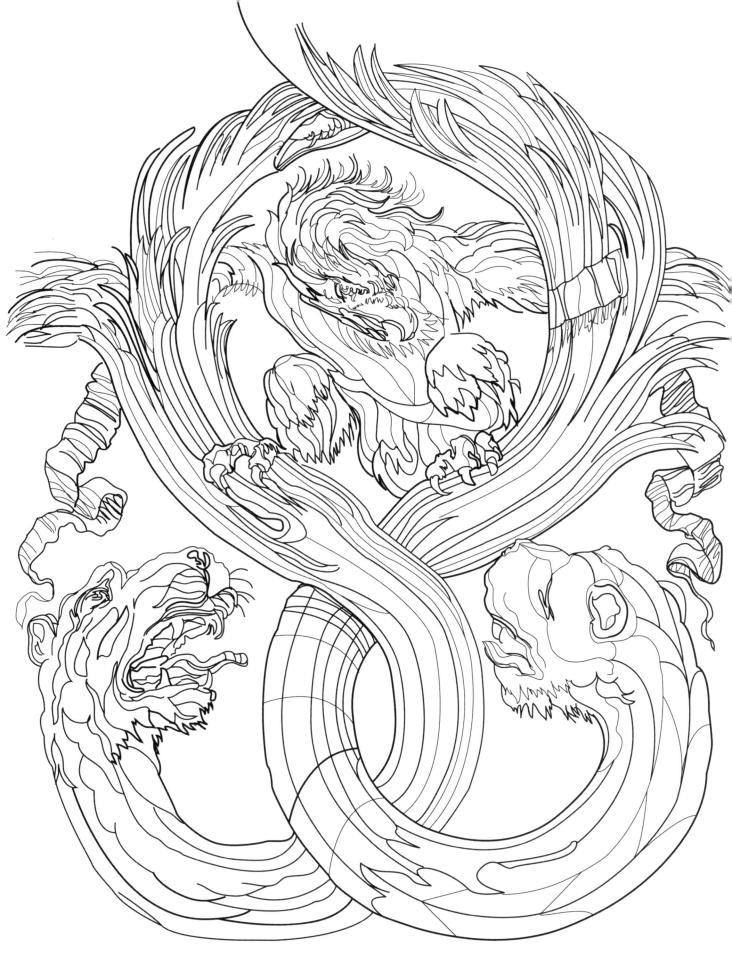

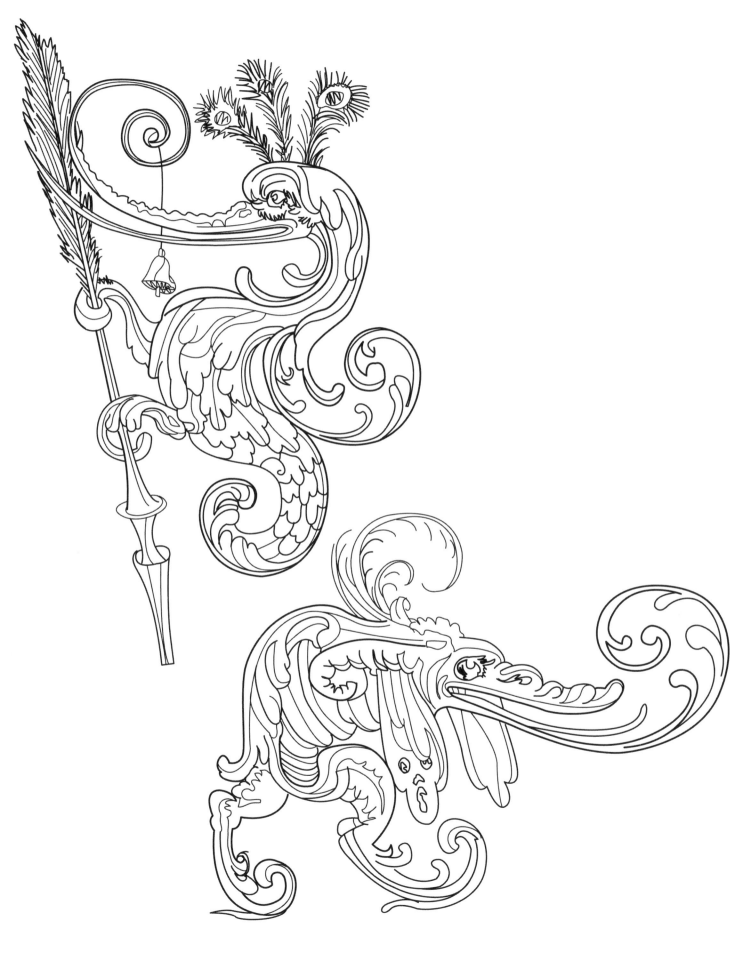

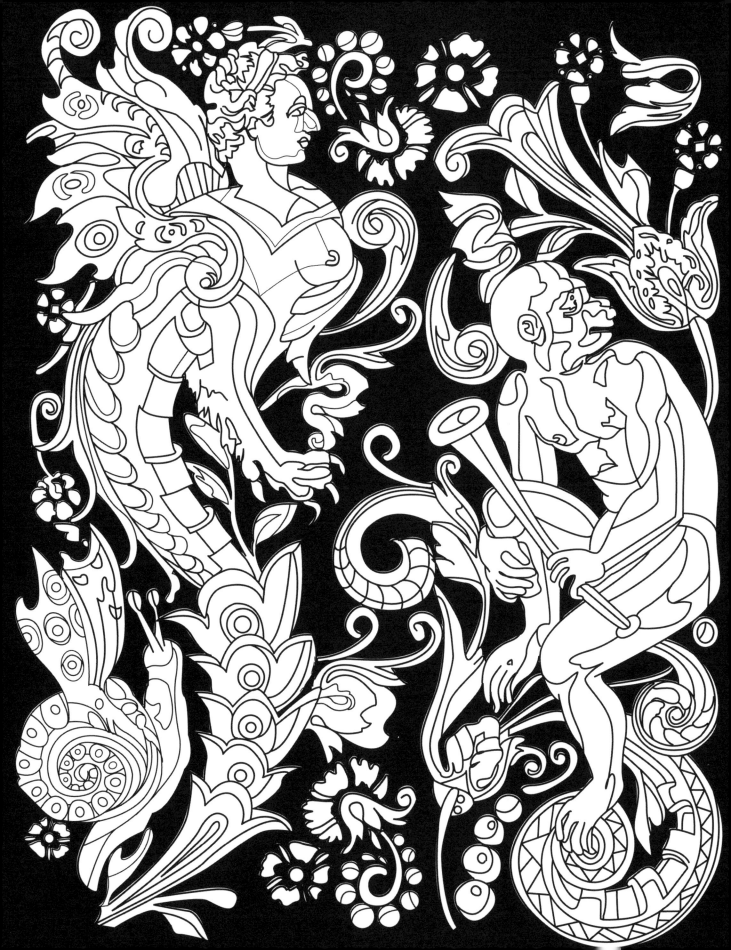

Sources
of
inspiration

Designs adapted from the following prints and drawings in the collection of Cooper Hewitt, Smithsonian Design Museum:

Ornament Panel Inscribed "Victoria Augusta," ca. 1507 | Nicoletto da Modena (Italian, active 1500–22) | Published by Antonio Salamanca (Italian, ca. 1500–62) | Engraving on paper | Museum purchase through gift of Eleanor and Sarah Hewitt, 1946-29-4

Grotesque Panel with Dolphins, 1527 | Lucas van Leyden (Netherlandish, ca. 1494–1533) | Engraving on paper | Gift of Leo Wallerstein, 1949-29-2

Grotesque Ornament with Satyrs, from a set of twenty ornament panels, ca. 1530–35 | Agostino Veneziano (Italian, ca. 1490–after 1536) | Published by Antonio Salamanca (Italian, ca. 1500–62) | Engraving on paper | Museum purchase through gift of Mrs. John Innes Kane, 1946-3-1

Plate, from a series of designs for ewers and vessels, 1548 | Cornelis Floris II (Flemish, ca. 1513–75) | Published by Hieronymus Cock (Netherlandish, ca. 1510–70) | Engraving on paper | Museum purchase through gift of Mrs. John Innes Kane, 1946-3-3

Design for a Pitcher, from *Insigne ac plane novum opus cratero graphicum* (A New Artistic Work, Eminent and Clear, on the Vessel), 1551 | Attributed to Matthias Zündt (German, ca. 1498–1572) | Engraving on paper | Museum purchase through gift of Mrs. A. Murray Young, 1946-37-1

Design for Stained Glass in the Laurentian Library, Florence, Italy, ca. 1570–80 | Attributed to Wouter Crabeth I (Dutch, active 1559, d. 1589) | Brush and brown wash, black chalk on paper, squared in black chalk | Museum purchase through gift of various donors and from Eleanor G. Hewitt Fund, 1938-88-7321

Orgueille et follie (Pride and Folly), ca. 1578 | Theodor de Bry (French, active Netherlands and Germany, 1528–1598) | Engraving on paper | Museum purchase through gift of Mrs. John Innes Kane, 1942-36-33

Sense of Sight, plate from *Quinque sensum typi in usum aurifabroru exarati* (Images of the Five Senses Engraved for the Benefit of the Goldsmith), ca. 1580 | Engraved by Crispijn de Passe the Elder (Dutch, ca. 1565–1637) after Heinrich Renbage (German, active ca. 1580–90) | Blackwork and engraving on paper | Museum purchase through gift of Mrs. John Innes Kane, 1945-6-2-b

Sense of Smell, plate from *Quinque sensum typi in usum aurifabroru exarati* (Images of the Five Senses Engraved for the Benefit of the Goldsmith), ca. 1580 | Engraved by Crispijn de Passe the Elder (Dutch, ca. 1565–1637) after Heinrich Renbage (German, active ca. 1580–90) | Blackwork and engraving on paper | Museum purchase through gift of Mrs. John Innes Kane, 1945-6-1-a

Plate, from *12 Stick Zum Verzaighnen Stechen Ver Fertigt* (Set of Twelve Designs for Engraved Vessels), 1580 | Bernhard Zan (German, active ca. 1580) | Punch engraving, pen and black ink, graphite on paper | Museum purchase through gift of Mrs. John Innes Kane, 1942-36-19

Plate 1, from a set of four frieze designs, ca. 1590 | Theodor de Bry (French, active Netherlands and Germany, 1528–98) | Engraving on paper | Museum purchase through gift of Mrs. John Innes Kane, 1942-36-26

Plate, from *Emblemata nobilitati et vulgo scitu digna* (Emblems Worth Knowing for Noble and Common Men), 1592–93 | Theodor de Bry (French, active Netherlands and Germany, 1528–98) | Engraving on paper | Museum purchase from General Acquisitions Endowment Fund, 1983-3-1

Plate 3, from a series of designs for sword handles, pommels, and dagger hilts, ca. 1615 | Antoine Jacquard (French, active 1616, d. ca. 1640) | Blackwork and engraving on paper | Purchased for the Museum by the Advisory Council, 1921-6-261-17

Plate 6, from *Neüw Grotteßken Buch* (New Grotesque Book), 1610 | Christoph Jamnitzer (German, 1563–1618) | Engraving on paper | Museum purchase through gift of the Estate of David Wolfe Bishop, 1957-162-22

Plate 30, from *Neüw Grotteßken Buch* (New Grotesque Book), 1610 | Christoph Jamnitzer (German, 1563–1618) | Engraving on paper | Museum purchase through gift of the Estate of David Wolfe Bishop, 1957-162-29

Plate 31, from *Neüw Grotteßken Buch* (New Grotesque Book), 1610 | Christoph Jamnitzer (German, 1563–1618) | Engraving on paper | Museum purchase through gift of the Estate of David Wolfe Bishop, 1957-162-28

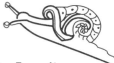

Plate 32, from *Neüw Grotteßken Buch* (New Grotesque Book), 1610 | Christoph Jamnitzer (German, 1563–1618) | Engraving on paper | Museum purchase through gift of the Estate of David Wolfe Bishop, 1957-162-30

Title plate, from *Die Folge der phantastischen Schmucksträße* (Suite of Fantastic Ornamental Bouquets), 1614 | Wendel Dietterlin the Younger (German, active 1610–14) | Etching on paper | Museum purchase through gift of Mrs. John Innes Kane, 1942-36-28-1

Plate 1, from *Die Folge der phantastischen Schmucksträße* (Suite of Fantastic Ornamental Bouquets), 1614 | Wendel Dietterlin the Younger (German, active 1610–14) | Etching on paper | Museum purchase through gift of Mrs. John Innes Kane, 1942-36-28-2

Plate 4, from *Die Folge der phantastischen Schmucksträße* (Suite of Fantastic Ornamental Bouquets), 1614 | Wendel Dietterlin the Younger (German, active 1610–14) | Etching on paper | Museum purchase through gift of Mrs. John Innes Kane, 1942-36-29-1

Plate 6, from *Die Folge der phantastischen Schmucksträße* (Suite of Fantastic Ornamental Bouquets), 1614 | Wendel Dietterlin the Younger (German, active 1610–14) | Etching on paper | Museum purchase through gift of Mrs. John Innes Kane, 1942-36-29-3

Pendant Design with the Temptation, Plate 1, from a series of eight pendant designs with the cardinal virtues, 1616–23 | Engraved by Johann Theodor de Bry (German, 1561–1623) after Daniel Mignot (French, active 1593–d. 1616) | Engraving on paper | Museum purchase from Drawings and Prints Council Fund, 2001-22-1-1

Pendant Design with the Virtue Hope, Plate 3, from a series of eight pendant designs with the cardinal virtues, 1616–23 | Johann Theodor de Bry (German, 1561–1623) after Daniel Mignot (French, active 1593–d. 1616) | Engraving on paper | Museum purchase from Drawings and Prints Council Fund, 2001-22-1-3

Plate 1, from a series of ornament designs for locksmiths, ca. 1615 | Antoine Jacquard (French, active 1616, d. ca. 1640) | Engraving on paper | Purchased for the Museum by the Advisory Council, 1921-6-261-15

Plate 3, from *Différens portraitz pour les serruriers nouvellement inventez* (Newly Invented Designs for Locksmiths), 1616 | Antoine Jacquard (French, active 1616, d. ca. 1640) | Engraving on paper | Purchased for the Museum by the Advisory Council, 1921-6-261-19

Plate, from *Ornamenti o grottesche* (Ornaments or Grotesques), ca. 1653 | Stefano della Bella (Italian, 1610–64) | Etching on paper | Purchased for the Museum by the Advisory Council, 1921-6-151-1

Plate, from *Ornamenti o grottesche* (Ornaments or Grotesques), ca. 1653 | Stefano della Bella (Italian, 1610–64) | Etching on paper | Purchased for the Museum by the Advisory Council, 1921-6-152-1

Plate 8, from a series of illustrations of a pageant on a church fiesta day, ca. 1600 | Francesco Valesio (Italian, born ca. 1560) | Engraving on paper | Museum purchase through gift of various donors and from Eleanor G. Hewitt Fund, 1938-88-8560

Plate 3, from *Diverses pièces de serruriers* (Various Designs for Locksmiths), 1662 | Engraved by Jean Bérain the Elder (French, 1640–1711) after Hugues Brisville (French, active ca. 1663) | Engraving on paper | Purchased for the Museum by the Advisory Council, 1921-6-261-3

Plate 7, from *Diverses pièces de serruriers* (Various Designs for Locksmiths), 1662 | Engraved by Jean Bérain the Elder (French, 1640–1711) after Hugues Brisville (French, active ca. 1663) | Engraving on paper | Purchased for the Museum by the Advisory Council, 1921-6-261-7

Plate 10, from *Diverses pièces de serruriers* (Various Designs for Locksmiths), 1662 | Engraved by Jean Bérain the Elder (French, 1640–1711) after Hugues Brisville (French, active ca. 1663) | Engraving on paper | Purchased for the Museum by the Advisory Council, 1921-6-261-10

Plate 11, from *Diverses pièces de serruriers* (Various Designs for Locksmiths), 1662 | Engraved by Jean Bérain the Elder (French, 1640–1711) after Hugues Brisville (French, active ca. 1663) | Engraving on paper | Purchased for the Museum by the Advisory Council, 1921-6-261-11

Plate 14, from *Diverses pièces de serruriers* (Various Designs for Locksmiths), 1662 | Engraved by Gabriel Ladame (French, active ca. 1645–68) after Hugues Brisville (French, active ca. 1663) | Blackwork and engraving on paper | Purchased for the Museum by the Advisory Council, 1921-6-261-14

Lion and Hare Composed of Ornamental Leaf-Work, from *Neue-ersonnene Gold-Schmieds Grillen* (New Designs for Ornaments in Gold), 1698 | Wolfgang Hieronymus von Bömmel (German, active ca. 1660–1700) | Engraving on paper | Museum purchase through gift of the Estate of David Wolfe Bishop, 1957-162-13

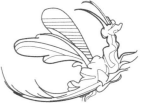

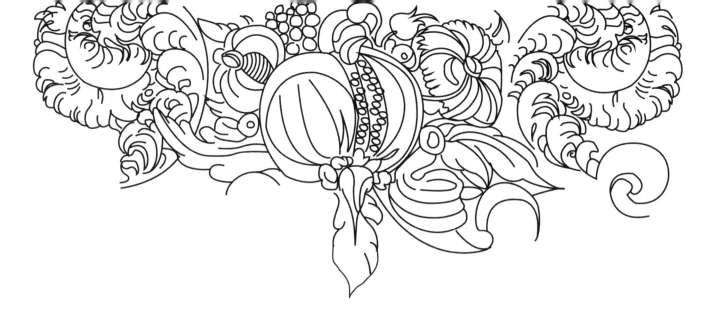

Magali An Berthon, Illustrator

Magali An Berthon is a New York-based surface designer and art director of French and Vietnamese origins. She has collaborated with numerous clients in France, the US, and Southeast Asia, including Kenzo, NellyRodi, Fondation EY France, Judy Ross Textiles, and Artisans d'Angkor. She develops collections of textile prints and designs for fashion brands; interior decoration, and trend forecasting agencies; and visual communication projects for cultural institutions. After earning a Master of Fine Arts degree in textile design at the National School of Decorative Arts of Paris, she studied textile history at the Fashion Institute of Technology of New York (FIT) on a Fulbright fellowship.

Caitlin Condell, Editor

Caitlin Condell is Assistant Curator of Drawings, Prints & Graphic Design at Cooper Hewitt, Smithsonian Design Museum in New York, where she has organized numerous exhibitions of art and design, including *Fragile Beasts* and the recent *How Posters Work* (co-curated with Ellen Lupton), *Maira Kalman Selects*, *Making Design*, and *Hewitt Sisters Collect*. At Cooper Hewitt, Condell oversees a collection of over 140,000 works on paper ranging from Italian Renaissance drawings to twenty-first-century digital graphic design. Before joining Cooper Hewitt, Condell worked at the Massachusetts Museum of Contemporary Art (MASS MoCA) and The Museum of Modern Art in New York (MOMA). Condell has contributed to many publications, including *How Posters Work* and *Making Design*. Condell received her master's degree in the History of Art from Williams College, and holds a bachelor's degree in Art History and Creative Writing from Oberlin College.

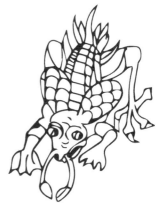